The Pathless Path
Moments with a Real Teacher

From Ancient Roots
A New Tree is Coming

Collected writings and Sculptures of I.M. Heer, 1967

Also by I.M. Heer:
"The Fish and the Magic Light"

To order additional copies of this book, contact:
Xlibris
844-714-8691
www.Xlibris.com
Orders@Xlibris.com

ISBN: Softcover 978-1-4415-0487-6
 Hardcover 978-1-4415-0488-3
 EBook 978-1-6641-2110-2

Library of Congress Control Number: 2009900484

Print information available on the last page

Rev. date: 12/07/2020

THE MEDITATOR

Questions and answers
Hidden in stone.
Ancient paths from the Bible
Too long overgrown.
With hands it is chosen
To expose an old WAY.
So that man can awaken
And learn how to pray.

"And Isaac went out to meditate
in the field in the evening;"
Genesis 24:63

Table of Contents

THE PATHLESS PATH

The PATHLESS PATH is hard to find.
IT climbs above the heart and mind.
IT goes so high that ONE can SEE
That I AM I, and 'he' is 'he'.

AUTHOR'S NOTE

The writings contained herein represent periodic moments in my life dating from the present time going back to April 1, 1967.

The writings are an attempt to use as few words as possible to try to express and explain an understanding of the need and urgency for each of us to seek a path that will lead us from this fleeting existence to a higher eternal "SENSE OF PRESENCE".

Words confuse: They cannot convey the 'taste' of chocolate. Actual prayerful effort is required for the "TASTE OF REALITY".

Realize that in these writings 'he' equals 'she' and 'man' equals 'woman'.

On a Higher Level HE equals SHE and both are embraced by I or ME.

PREFACE

This book is for the 'child' that lies sleeping within each of us. The writings are an appetizer designed to whet your appetite for the main course — a course that sits out there waiting to be discovered. Read this through in three or four sittings.

If you then feel that there is an understanding to be gained and a mystery to be solved reread this more slowly—perhaps one chapter at a time.

Then, lastly, open to a page at random. Ponder quietly what you have read. Observe your thoughts, feelings, and physical sensations.

Rx Repeat this once a day as you feel necessary.

The scientific researcher starts with a theory—"There is a SOUL OR BEING within this body that can be 'experienced' as a fact." Through properly guided Effort or Prayer the individual must seek the WAY to establish this TRUTH for ONE'S SELF.

Wish for a teacher—a REAL TEACHER—with PATIENCE, PERSISTENCE, and COURAGE.

CHAPTER 1

WHO AM I?

A GUIDED TRIP To an INNER KINGDOM

Come with ME. Come with ME to the center of the Earth—the Earth that is your individual body. For YOU are, in so doing, fulfilling the most important purpose of YOUR EXISTENCE on this planet. To perfect and cleanse YOUR SOUL and in so doing establish a connection with a HIGHER WISDOM that can "turn swords into plowshares" and bring us the dreamed for "peace on Earth, good will amongst men".

For YOU are not the body! YOU exist apart from but attached to the body and YOUR prayers must take the form of REAL SPIRITUAL WORK. It is a WORK that requires repetition so that it becomes a PROCESS leading firstly to a MOMENTARY EXPERIENCING OF REALITY. Continued EFFORT leads to an AWAKENING which comes within the context of what this three-dimensional mind thinks of as time.

MEDITATION is a higher form of prayer. Learn how to MEDITATE. Seek a REAL TEACHER. MEDITATE as a Christian, a Jew, a Moslem, a Hindu, a Buddhist, or whatever other faith you identify with. MEDITATE as a rich man a poor man, a white man a black man, a president a laborer, a man a woman. Bring YOUR ATTENTION to the body. SEE how it thinks, it feels, it aches, it likes, it dislikes. Look at this IMPARTIALLY — do not judge what YOU SEE. KNOW that in order to KNOW YOUR REAL SELF YOU MUST SEE "what YOU are not". The 'part' YOU have been given in the present lifetime has a beginning and an end. With patient and persistent EFFORT YOU have the possibility of REALIZING YOUR ETERNAL NATURE.

ETERNAL I in time

The leaf falls gently from the tree
And as it does it's telling ME
That summer's gone and autumn's near
And so begins another year.
A year of joy? A year of pain?
Sunshine, clouds — and once again
A leaf shall form — a leaf shall die
And I'll still wonder, "WHO AM I?"

A SIP OF THE ETERNAL

I seek a sip of the ETERNAL
While wrapped in mortal dust.
Is there a pathway to it?
Is it joyful? Is it just?
Is it strewn with success and failure?
Times to work and times to rest?
Grant me the REAL QUESTIONS.
And with TRUST may I be blessed.

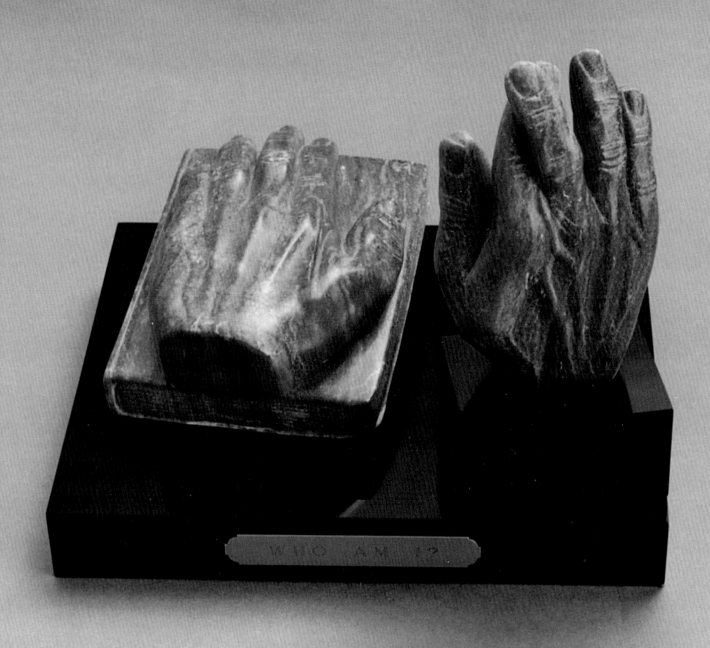

Pondering the Situation

Everything appears finite.
Every suffering or joy has a beginning and an end within an all encompassing beginning and end of my present life on Earth.
Therefore, where is there any lasting or infinite meaning?
Is there SOMETHING in me that relates to the INFINITE?
Can I KNOW this SOMETHING?
Can I call this SOMETHING my REAL SELF?
How would I EXPERIENCE this REAL SELF?
Would the EXPERIENCE be a GLIMPSING of REALITY or would it be PROLONGED?
And in KNOWING MYSELF would I be closer to UNDERSTANDING all the other REAL QUESTIONS that burn inside ME?

THE CLIMB

Imagine a cone-shaped mountain. Name it THE MOUNT OF WISDOM AND UNDERSTANDING. Now imagine four men standing at the base of the mountain separated and equidistant from each other. As each of them look upward they see in the thick tangled underbrush nearest the base where they are standing a separate almost indiscernible STRAIGHT AND NARROW PATH. They start to climb, brushing aside the 'branches and undergrowth' of vanity, prejudice, preconceived ideas, which attempt to hide these PATHWAYS to higher KNOWLEDGE and UNDERSTANDING. As they climb higher they begin to experience less and less the interference from the 'foliage' they experienced at lower levels. The PATH becomes clearer the higher they climb. Upon nearing the top they experience the realization that the PATHS are in fact BEING drawn together. They can begin to understand what a BEING to BEING relationship might BE. All differences of race and religion, so divisive at the base of the mountain, have given way to an approaching ONENESS realized fully with the REDEMPTION or REBIRTH of the SOUL that reaches the peak.

THE House OF PRAYER

If my body is a temple
Can I KNOW 'it' from my SOUL?
Is there then a PATH to take
That I fulfill GOD'S goal?

And if I rather think myself
A mosque — perhaps, a church.
IS not the body still the same
In which I have to search?

Thoughts and feelings differ.
Aches and pains exact their toll.
I WORK to SEE this "House of Prayer"
To KNOW it's not the SOUL.

Many Rituals — One Truth

Bring ME not to my knees
With tragedy and grief.
But rather Lord, please find ME there
With BEING and BELIEF.

Oh Lord I stand before the wall
While swaying to and fro.
Oh Lord I pray for WISDOM
My TRUE SELF I wish to KNOW.

Prostrate upon my prayer rug
With my body facing East.
My SOUL within me hungers
Upon WISDOM may I feast.

There are many PATHWAYS up the mountain
But when all is said and done
No matter what the differences be
They lead to GOD WHO'S ONE.

Some Musings

WHO AM I?
> AM I a prisoner?
> A prisoner of this body with its pain, fears, thoughts, joys and sorrow?

WHY AM I HERE?
> To endure? To engage myself in this PROCESS of attaining self knowledge?
> What would it mean to ME to EXPERIENCE my REAL SELF
> for just a MOMENT?
> Would it not be the greatest joy to KNOW that I AM 'not' the mortal material I
> SEE? Is this REAL SELF eternal?

WHAT IS REQUIRED OF ME?
> To "sleep" or not to "sleep"?
> To "WORK" or not to "WORK"?
> To "BE" or not to "BE"?
> When? For how long? To have the courage to try while acknowledging that with
> the passage of time I seem to grow in KNOWING MYSELF more while there is a
> concurrent growth of interest in holding onto the REAL QUESTIONS.

THE 𝕱ALSE SHEPHERD

A FATHER had two sons — each of whom HE loved equally. One day HE came to them with an important request. It seemed that the water in the family well would soon run dry and HE requested that they separately start to dig two new wells in search of a fresh supply. To each son HE designated where they should start to dig and suggested that they dig in a 'straight line' directly downward. More importantly HE gave each of them a SPECIAL TOOL, of ANCIENT HERITAGE, that had been designed especially for the task at hand. HE explained that as they dug deeper they would notice 'small but periodic evidence of moisture' which should reassure them that they would be successful with continued PERSISTENCE.

The younger of the two brothers, however, soon grew impatient. Being in a hurry for success he did not take note of the 'signs of moisture' he passed in his digging. Seeking what he thought might be a better way, he decided to visit a friend who lived nearby who had recently published a book on "The Art of Digging a Well". The friend was happy to sell him a copy of this now famous best seller—for an exorbitant price – and the younger brother read it over and over again with great enthusiasm. He began to realize that, with all his reading, the actual technique needed to dig the well was shrouded in vagaries, and so he decided to return and confront his friend with some particular questions. The answers were not forthcoming and when he finally asked to see his friend's well, the friend confided in truth that he had no well and that the source of the water he drank came delivered in bottles weekly from a well dug by his former mentor and guide.

The younger brother returned disheartened and started to dig at the site designated by his FATHER but soon grew impatient for results. Off he went again but soon returned disappointed. This pattern of behavior on his part, although not finding 'pure' water, began to enable him to discourse at length about all the various pathways to success. He learned all the right words and became such an engaging speaker that he soon became famous, and his lectures, though expensive, were overly subscribed to all over the world. In time he drifted away from his FATHER and drowned, not in water, but in the adulation and praise of his fellow man.

The older brother who stayed with the task originally proscribed by their FATHER achieved the success promised. HE remains close to the FATHER and for the most part speaks sparingly and not too often.

𝕳IGHER THOUGHTS ENTRENCHED IN TIME

You give me words to write in rhyme
Of higher thoughts entrenched in time.
That tell of paths—of ways unknown
Where life's fulfilled and seeds are sown.
To wake the souls that lie in sleep
To appointments now they need to keep.
To see ONE'S part—to see the play
The need for efforts made each day.
The climb is steep—ONE needs a GUIDE.
There is no failure when ONE'S tried.

CHAPTER 2

WHY AM I HERE?

LOOKING FOR MEANING

Injustice here goes round and round
And Peace on Earth is rarely found.
COMPASSION sleeps — and hate is fed
And MERCY now is all but dead.

What purpose lies in all this mess?
Chaotic life — directionless.
Existence filled with grief and fear
I ask THEE LORD, "WHY AM I HERE?"

A PROCESS in time

THE PURPOSE OF LIFE LIES IN PRAYER.
OUR EFFORTS ARE OUR PRAYERS.
THEREFORE, LIFE'S PURPOSE IS FULFILLED WITH EFFORTS.
THESE EFFORTS AND THEIR NATURE MUST BE BROUGHT TO MAN AND WOMAN.
ONE MUST BRING A BODY, A SOUL, AND A DESIRE FOR TRUTH.
THE EFFORTS OVER TIME BECOME PART OF A PROCESS.
A PROCESS WHICH LEADS FIRSTLY TO A GROWTH OF KNOWLEDGE AND UNDERSTANDING.
A PROCESS WHICH CAN LEAD TO THE APPEARANCE AND THEN THE GROWTH OF BEING.
REAL TEACHERS ARE NEEDED — TEACHERS WHO KNOW THEMSELVES.
AND STUDENTS WHO ARE ABLE TO RECEIVE THE "BATON OF BEING".
THUS, A LINK OF BEING SHALL EXTEND FROM GENERATION TO GENERATION.
Would this put in place a stronger more lasting connection to our CREATOR? And would this increased ONENESS lead to a disappearance of war and injustice?

The EFFORT that is PRAYER

It is the duty of man to KNOW WHO HE REALLY IS and WHO HE IS NOT. And in order to KNOW HIMSELF he must first WORK to find out WHO HE IS NOT! That WORK — almost completely unrecognized by so-called modern man — is REAL PRAYER. It is PRAYER in its HIGHEST FORM.

A TOAST

Not to worshipped idols.
Not to joy or strife.
Not to things — either good or bad
But to this 'mystery' called LIFE.

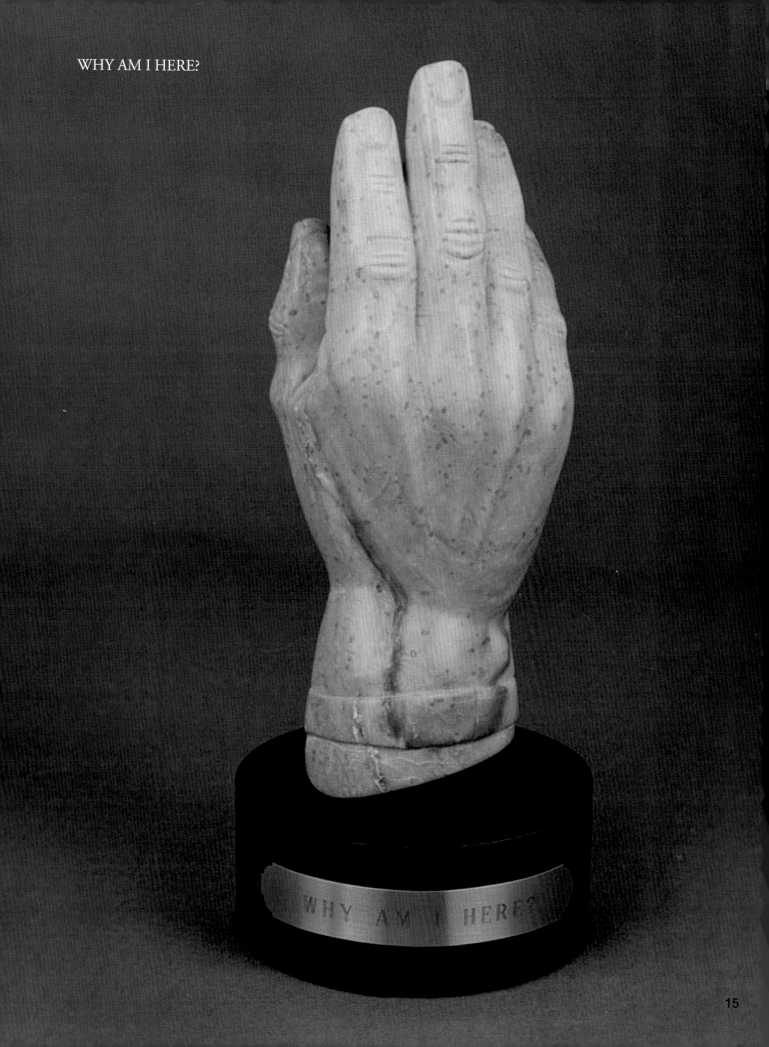

SHOW ME THE WAY TO GO HOME

The LORD was in HIS HEAVEN
And my SOUL was in HIS HAND
As HE gazed among the planets
For the one my life HE'd PLANNED.

And HIS EYE was cast upon the Earth,
And into my mother's womb.
Where with HIS PRAYER HE placed ME
For my SOUL this was a tomb.

For many months I rested
With the question, "Where AM I?"
And "AM I going home to THEE?"
Or "AM I about to die?"

I soon received my answer
As I entered planet Earth
With the terror that makes most babies cry
I began the 'death' called "birth."

I was now entrapped in senses
And a form which most confused.
But with time and loving parents
I soon was much bemused.

And so, alas, the years went by
And I forgot my fear.
And also the sacred questions,
"WHO AM I?" "WHY AM I HERE?"

A TOAST

To REAL BIRTHDAYS
ARRIVED at SLOWLY and GENTLY.
GUIDED there with a HIGHER WISDOM and
UNDERSTANDING.
ENDURED with PATIENCE, PERSISTENCE, and
COURAGE.
And BLESSED by MERCY, COMPASSION, JUSTICE, PEACE,
HEALING, and FORGIVENESS.

The HIGHWAY

When a REAL question is carried within yourself the REAL answer is suggested with the appearance of my REAL SELF — the "I AM THAT I AM". It is a KNOWING accompanied by ONE's UNDERSTANDING. It is to BE EXPERIENCED.

At the earlier stages of ONE'S search this 'momentary, fleeting answer' can be looked upon as a GIFT for sincere EFFORTS made in time. PERSISTENCE with GUIDANCE from a TEACHER is necessary.

Beware of 'false shepherds.'

Beware of 'spiritual greed' — for 'grasping' for an 'answer'.

Along with ONE's EFFORT it is better to SEEK and DEEPEN the REAL questions while being wary of answers that may be tainted by 'earthly' thoughts, feelings and sensations.

THE EXPERT TREE

A man once had an Expert Tree.
With fruit it did abound.
And when the Tree was in full bloom
All ONE's answers could be found.

Now when the fruit did ripen
It fell upon the earth.
From whence the wind would spread the seeds
And so began new birth.

The Trees were now found 'round the world
And wherever ONE did go
YOU could always find an Expert Tree
Spouting 'WISDOM' it did not KNOW!

Now just like the famed false shepherd
The Expert Tree led men astray.
Until the day of mass mutation
When REAL QUESTIONS saved the day.

REPEATING
Some REAL QUESTIONS

WHO AM I?
WHY AM I HERE?
WHAT IS REQUIRED OF ME?
WHAT DO I NEED?
HOW CAN I SHARE?
WHAT IS MY PLACE?
WHAT IS POSSIBLE?
WHO GUIDES ME?

THE RETURN

Once upon a time in a far away galaxy, there lived a group of BEINGS whose existence was being threatened by a change in the axis of their planet. It was decided by the chief thinkers living there that a group of the younger, more physically vigorous members of their family, be sent out into the universe to investigate the possibility of existence elsewhere in friendlier surroundings.

And so it was done. A group of thirty-two were given provisions and transportation and they left the elders behind pledging never to forget them and their ONE FATHER. After traveling many light years they came upon the planet SOMNIA which physically in many ways reminded them of home. Upon disembarking they found the actual environment much too harsh for the fine outer coating of their BEING BODIES. Their decision to return to the ship was interrupted, however, when they fell into the hands of a group of much denser BEINGS who immediately placed them into a dark and dismal prison. Each one of them was placed into a separate cell and although the cells were adjacent to one another communication was very difficult.

Time passed, and with its passing they soon forgot their mission and the pledge to their families and the ONE FATHER they had left behind. All their perceptions changed. They viewed the universe through the 'five tiny slit-like windows' in the outer wall of their cells and as a result soon began to live their lives surrounded by fear, imagination and suspicion. The walls of their cells seemed to close in on them and in a way become part of them.

Now this prison was built in a not too uncommon way. The outer wall, which separated the prisoners from a true understanding of the universe, was many more times thicker than the walls existing between the cells. It occurred to the wiser among them that if they could break down the walls between them with a proper EFFORT, then that same EFFORT made as a group would leave the outer wall more susceptible to their penetration. And so they WORKED—they WORKED for years. Progress was slow and often discouraging. But as they WORKED they began to notice in themselves a 'taste' — a REMEMBRANCE of the PEACE and MERCY that once was so very much a part of their ordinary existence. Then one day, when hopelessness had all but triumphed, a pinpoint of blinding LIGHT shone forth from the end of the tunnel where it met the outer edge of the outside wall. As their many years of imprisonment had left them physically incapable of enduring the brightness and heat of such a LIGHT they decided to first ponder the wisest way to deal with this problem. Many suggestions and much thought was given to help evolve a solution. It seemed for a while that their deliberations would last longer than the time it took to create the tunnel originally. Finally, a relatively simple answer was found. It was decided that each of them in turn would seek exposure to the LIGHT for only a few moments at a time and then return to the others and report his experience. Over a period of time, those that were able were allowed to gradually increase this exposure and as this was done they all began to note a rekindling of MEMORIES of those they had left behind and of the ONE FATHER who seemed to be calling them.

This practice continued. It began to be realized that a chosen few were able to bear the LIGHT EXPERIENCE increasingly over a span of time. As they did so they were able to share with the others the feeling that they were drawing closer and closer in some strange and inexplicable way to the ONE FATHER who had sent them all. What happened next was completely unexpected. One of those who had been given the ability of STRONG-LIGHT-ENDURANCE went forth to take his place at the end of the tunnel where it met the outermost edge of the outside wall and where the LIGHT was the brightest. For some unknown reason HE was swept out into the LIGHT and disappeared. There was a terrible sense of loss amongst his brothers and sisters. HE

had been an increasing source of UNDERSTANDING for them and grief was evident everywhere. They began to drift away from their common EFFORT and returned to their individual cells. They forgot again all that they had originally pledged not to forget. The tunnel remained in tact but was rarely used and the KNOWLEDGE that had come from the LIGHT ceased to be sought.

The reappearance of their lost brother caused much consternation amongst the group. Joy was mixed with a deep sense of remorse because HIS return reminded them of the RIGHT EFFORTS they had abandoned with his disappearance. They began to notice, too, that although HE looked the same, HE now came dressed in finer garments and seemed imbued with an AURA OF LIGHT similar to but not as bright as the LIGHT outside the wall. But more importantly they noted HIS SPEECH. HE spoke with an AUTHORITY that none could doubt. HE spoke of the NEED of the ONE FATHER to SENSE THEIR PRESENCE through their own EFFORTS to SEEK the LIGHT and the TRUTH that lay within them. He spoke of LOVE and PEACE, of MERCY and COMPASSION, of JUSTICE and HEALING and FORGIVENESS. And his words welded the many into a ONENESS which allowed them each in his own time to pass from the cell that was a prison to be joined again with the family and the ONE FATHER they had thought never to see again.

A DIRECTION

What is TRUTH? What does it mean to KNOW THYSELF?

There are no words to answer these questions in the spiritual sense in which they are asked.

TRUTH EXISTS. TRUTH IS. To EXPERIENCE TRUTH or KNOWLEDGE of THYSELF is an answer which deepens and broadens the REAL questions.

How can man come to this experience?

By WORK. To WORK means to struggle to KNOW THYSELF — to separate THYSELF from 'myself' — the 'myself' that walks the Earth's stage as a 'sleeping' actor or actress.

Do I PLAY the part or does the part 'play' ME?

The human BEING needs a REAL TEACHER and other SEEKERS, along with PATIENCE, PERSISTENCE, COURAGE, FAITH and TRUST in GOD that ALL EFFORTS serve a HIGHER NEED.

I and THOU

O FATHER show ME what to TRUST
That I not go the way of dust.
To have the PATIENCE and to SEE
The part that has been PLANNED for ME.

THERE IS

There is,
> A time to live
> A time to die.

> A time to laugh
> A time to cry.

> A time for truth
> A time to lie.

> A time to sell
> A time to buy.

> A time to rest
> A time to try.

> A TIME TO ASK
> > "WHO AM I?"

THE SCULPTOR

For ME the TRUTH is not for writing.
Nor is it in the spoken word.
For man, himself, would never 'taste' it,
He might simply think, "Why that's absurd."
So, thus, I carry TRUTH within me
ALONE within myself.
To speak with stone and chisel
And put it on the shelf.

SEEK the REAL TEACHER

You can probe for the TRUTH with your mind and feelings but it is only when you bring in YOUR ATTENTION to your physical body that the spiritual climb up the side of the mountain can begin.

CHAPTER 3

WHAT IS REQUIRED OF ME?

Seeking Parole for the Innocent

MY SOUL cries out from prison
With pleading and with fear.
And MY cries they are not answered.
It seems there's no ONE near.

So I take this pen to write YOU
And put MY prayers in rhyme.
And ask, "Why life's injustice?
Am I guilty of a crime?"

Life must have some hidden purpose
Thoughts and feelings cannot find.
So LORD if YOU are listening
Show ME the PATH that I must find.

Ancient Paths lead to Higher Levels

What is required of ME?
This question had been bequeathed to ME as the most valuable in my TEACHER'S estate.
What interests ME in this question is the ME.
The BEING EFFORT we make derives from 'ancient teachings' designed to demonstrate the mechanical nature of the human form. Continued EFFORT has the possibility of revealing the MIRACULOUS MOMENT – the GLIMPSE of the TRUTH — which can confirm through EXPERIENCE the existence of 'something' on another LEVEL — ME!
Can I theorize that this REAL SELF — this "I" — is 'not' irrevocably linked to this mortal mechanicality? And if so, why is this REAL SELF here on earth?
Is there an obligation to BEING EFFORT not perceivable to the three-dimensional structure we inhabit?
Would this BEING EFFORT if performed by an increasingly AWAKENED humanity bring the dreamed for "peace on earth, good will towards men."?

Beware of false shepherds

The TRUTH cannot be expressed nor explained satisfactorily in words from ONE WHO KNOWS to ONE WHO WISHES TO KNOW.

And what is there to KNOW? Only MY REAL SELF, MY SOUL, MY BEING and THE WAY to this REALIZATION as provided by a REAL TEACHER.

It is only the EFFORT to SEARCH that can bring comfort amidst turmoil as well as KNOWLEDGE and a deeper UNDERSTANDING of the ANCIENT PATHS. Seek those who have a similar thirst for an INNER PEACE and PRESENCE and together seek the TEACHER.

PRISON CONDITIONS

Titles not easily readable on the sculptured books in the photograph
are from left to right:
"MAN AND HIS THOUGHTS"
"MAN AND HIS FIVE SENSES"
"MAN AND HIS FEELINGS"
Also, there are five chains in all, running from each book and the two
HANDS to the lock in the center. Note the key to the lock on the
back wall is in the form of a question.

*"to open the eyes that are blind, to bring out
the prisoners from the dungeon, from the prison
those who sit in darkness."*

ISAIAH *42:7*

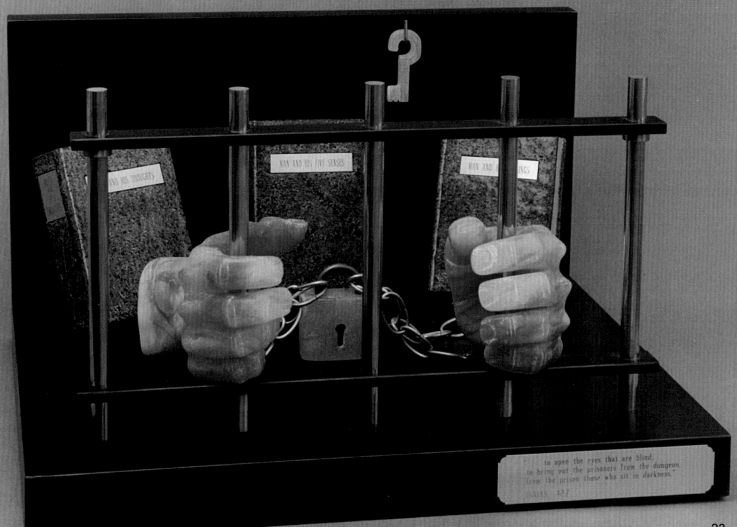

𝔉ree ME from

Free ME from the joy,
the sorrow.
Free ME from today,
tomorrow.
Free ME from the "bad,"
the "good".
Free ME from "I can't",
"I should".
Free ME from the "yes",
the "no".
Free ME from the friend,
the foe.
Free ME from "be brave",
the fear.
Free ME from all "things"
held dear.
Free ME, simply let ME BE
THAT I MIGHT TASTE ETERNITY.

The 𝔚AY to REALITY and

OUR EFFORTS ARE OUR PRAYERS.
WE attempt by this EFFORT to KNOW OUR REAL SELF.
At the beginning WE can have the POSSIBILITY of EXPERIENCING only MOMENTS OF REALITY.
Over time, with patience, persistence and PROPER GUIDANCE more is POSSIBLE.
What can this KNOWLEDGE OF MY REAL SELF mean to ME?
Will this EFFORT prove that this body is an amazing machine — a computer-like device that is mortal?
Can the 'TASTE' of MY REAL SELF suggest that, perhaps, MY FATE can be different from that of the body?
And with the KNOWLEDGE OF MY REAL SELF would the REAL QUESTIONS take on greater urgency?

𝔖IMPLY SEE AND 𝔖IMPLY BE

For many years you simply SEE.
Then with REBIRTH you simply BE.
Simply SEE — then simply BE.
In the given part not writ by ME.
And so with PRAYER YOU pay the fee.
That sets the SOUL from body free.
To serve the LORD with simply BE.
YOU'LL KNOW this poem is not from me.

THE ℰXPANDING UNIVERSE

The PUPPETMASTER was deeply perplexed. The SUPREME CREATOR of all puppets had sent HIM to the outer reaches of the KINGDOM OF BEINGNESS to establish, on the remote sphere called Somnia, HIS BENEFICENT PRESENCE. The PUPPETMASTER knew that the WILL of the CREATOR would make itself realized by way of a BEING transmission passed through 'invisible wireless strings' to the puppets HE had placed there.

Alas, something seemed to have gone awry. Transmission of HIS WILL, which was to be supported by a script of PEACE and ETERNAL PROSPERITY designed to evoke appreciative MEDITATIVE EFFORT, did not occur. The idea of ONENESS, originally implanted in their forms, had been introduced to make the puppets have an AWARENESS of the 'invisible wireless strings' and of the importance of BEING EFFORT needed to sustain them. Without EFFORTS Somnia and its inhabitants began to lose their connection to the rest of the KINGDOM OF BEINGNESS. The transmission from above lost its clarity and the puppet-BEINGS began to wallow in the 'empty' rituals and the words and interpretations of their three-dimensionally based teachers.

This problem was not new. Similar past attempts to expand the KINGDOM at its periphery had had the same result. Experience had shown that the solution rested simply with an increase in the intensity of BEINGNESS being transmitted. On this occasion, however, the problem continued to persist. Newly written and harsher scripts were produced and still there was little to no BEING EFFORT made in response. The puppets were afflicted with BEING-SLEEP and even with these new three-dimensional scripts filled with war, disease and injustice there was no SPIRITUAL AWAKENING. The few old bastions for REAL TEACHINGS, long protected by the PUPPETMASTER, were now being destroyed by the 'disconnected' puppets run amok.

A meeting of HIGHER BEINGS was convened by the SUPREME BEING.

ARCHPUPPETMASTERS came from all corners of the KINGDOM OF BEINGNESS. A solution was proposed and instructions passed down through BEING LEVELS to the PUPPETMASTER in charge of the non-evolving puppets of Somnia. New puppets were to be constructed. These puppets, now capable of receiving stronger BEING transmissions, were all sent to reside in a very localized area. The area designated had in the past been a very strong focal point for both the reception and return of BEING EFFORTS. This combination of changes led to the reestablishment of an intense laser-like return of BEING-EXCHANGE through the 'invisible wireless strings'. Along with PATIENCE, PERSISTENCE and COURAGE the AWAKENING of puppets spread GRADUALLY across Somnia. Differences in rituals and ceremonies were SEEN to hide the ONE TRUTH that was at the core of each religion. With MEDITATIVE EFFORT hatred, prejudice, greed, war and injustice all disappeared. BEING EFFORT became a normal INNER ACTIVITY within all scripted outer activity. Somnia was now embraced by the WILL and PRESENCE of the SUPREME BEING which in turn brought the PEACE and PROSPERITY originally envisioned.

𝔍OY

What greater joy can there be than to share the THOUGHTS GOD'S given ME.

'It' AND I

'It' asks for this
'It' prays for that.
A brand new car,
A house, a flat.
Money, clothes,
Baubles, beads.
A hungry ego
On this feeds.
Well-fed ego
Now grown fat,
'It's' gotten all
Of this and that.
But deep inside
There is no joy,
Materially swamped
With every toy.
Happiness, PEACE
Still out of reach,
Desires change
And I beseech
To find a PATH
A WAY OF PRAYER
From ego freed
Allowed to share
In KNOWLEDGE, BEING
Most desired.
And questions such as
"WHAT'S REQUIRED?"

BEING ME

Some men go to temple.
Some men go to church.
Then there are those such as ME
Left alone to search.

Some men pray by kneeling.
Some men sway to and fro.
Then there are those such as ME
Who pray where e'er they go.

Some men find peace in sacred rites.
Some men in old traditions.
Then there are those such as ME
Who seek THEE in all conditions.

Awake, awake, put on strength,
O arm of the Lord;
Awake, as in days of old,
The generations of long ago.
ISAIAH *51:9*

Awake, awake, put on strength,
O arm of the Lord;
awake, as in days of old,
the generations of long ago.

ISAIAH 51:9

Man's Mind and 'its' Limitations

The mind of man is clever.
It's invented many things.
Medicines that cure the sick
And airplanes without wings.
Computers, now, that I hear tell
Are programmed how to think.
And saltwater from the oceans
Made suitable to drink.
But of all the things this mind did make
It never could invent
That fleeting SPECIAL MOMENT—
A GIFT that's HEAVEN sent!

The Overused 3-Dimensional Tool

Nothing so thwarts the SEEKER of TRUTH
Than the glare of his brilliant mind.
For it is not the tool with which HE must dig
To uncover the FACT HE must find.

The Intellectual Spins a Web

The more a man 'thinks' that he has all the answers to life's mysteries the further he is from his CREATOR.
This is especially so of the 'thinking man' who proclaims that the PATH or WAY that he is on is the 'only' WAY. In so doing, he will more than likely take the words of the REAL BOOKS and with his three-dimensional mind wrongly interpret the words. Thus he weaves a web as does the spider — except in this case he is not only the trapper but the trapped.

Vanity's Palace

Holiness lies not with bricks and stones
But rather is hidden in ONE's bones.
So vanity's palace built for the SOUL
Feeds ego first—defers the GOAL.

CHAPTER 4

WHAT DO I NEED?

A Way in LIFE

Bring this EFFORT into your day.
SEE yourself at work — at play.
Now you're sitting — now you stand.
Watch the movement of your hand!

The recluse he sits in isolation.
Has little stress — no tribulation.
No nine-to-five and thus he's freed
From meeting family's earthly need.

But YOU whose script is filled with strife.
No time for prayer — asleep in life.
A saintly BEING try to BE.
To find a PATH to set YOU free.

A Definition

A REAL TEACHER KNOWS HIMSELF and in that KNOWING understands that HE is but a witness and not the SOURCE of the KNOWLEDGE and UNDERSTANDING that HE shares with those GOD has chosen to receive.

Spiritual Levels

Once upon a time, not too long ago, a group of men hearing of a gold strike not far from where they lived decided they would forego their present secure positions in life and go and seek their fortune. Being practical men they realized that they knew nothing about how to pan for gold — nor could they be sure to recognize the metal in its natural form even if they came across it.

They decided, therefore, to seek and find a man experienced in this field — a man who knew both how to find and recognize the prize they were all hoping to acquire. After some time such a person was found — a prudent man who decided that wisdom decreed that their education and search be conducted in such a way that they be able to remain in their present life circumstances. He decided that his pupils use most of their evening and weekend time to foster a concerted effort. And so it developed in time that they found themselves at a higher elevation in the nearby mountains panning for gold.

The teacher's function at this time was to distinguish what was a REAL find from the fool's gold that abounded all around them and in this capacity he performed well. However, what was not realized was that the preciousness and worth of the gold to be discovered was small compared to the diamonds that were also present in limited quantities. In this respect our well meaning guide was of no help — for he was unable to recognize the purity and value of a diamond when it was brought to him. He simply dismissed it as a piece of worthless glass! The GUIDE, WHO KNOWS HIMSELF, recognizing the GREATER GIFTS, would have been able to lead SOME of HIS pupils to the higher levels on the mountain where an increased supply of these precious and pure discoveries were waiting to be found.

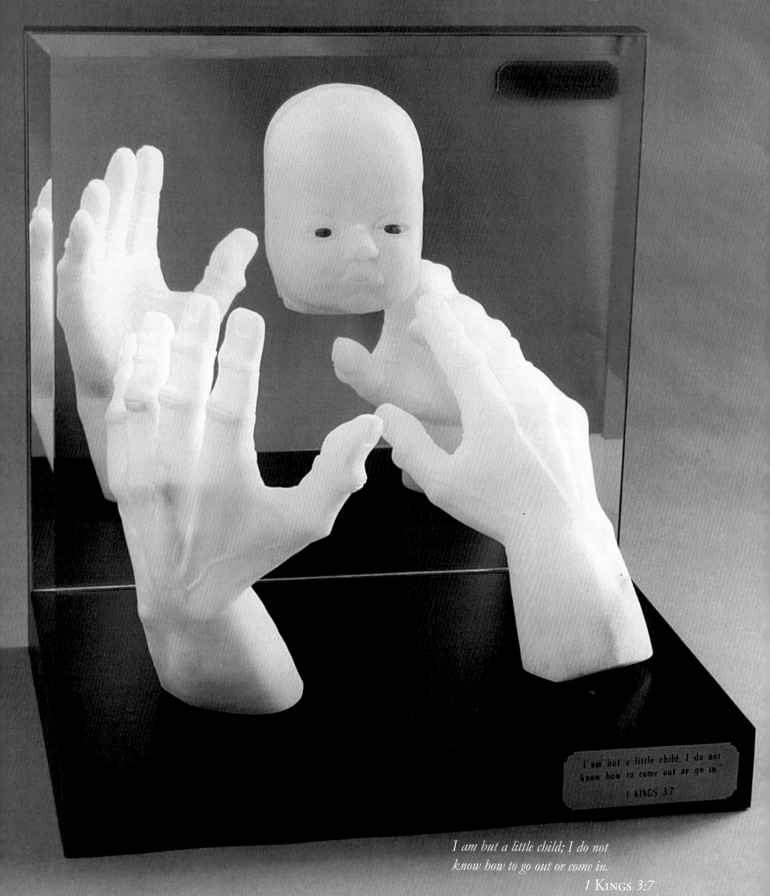

*I am but a little child; I do not
know how to go out or come in.*
 1 Kings 3:7

CHASING AFTER WIND

My life is making money.
That's the part I've had to play.
This fills all waking hours.
How I spend both night and day.
But it seems there's something missing.
Satisfaction is not there.
I wish to find some balance.
A PATH, a WAY OF PRAYER.
Let ME seek the RIGHTEOUS TEACHER
and the MOMENT that's so rare.
That KNOWLEDGE of MY REAL SELF
With others I CAN SHARE.

PAY ME NOW OR PAY ME LATER

If my life was filled with joy
And free from fear and sorrow
Would I try to pray today?
Or would I say, "tomorrow"?

A PLANET AT PEACE?

Is there order in this chaos?
Are things not what they seem?
Is the killing, hate, and evil
Just a nightmare, just a dream?
Then what meaning lies behind
This existence filled with grief?
That can justify my living
For higher purpose and belief.
I seek an understanding
That I fulfill some higher goal.
A PATH that's sure to lead ME
To the REAL SELF that is my SOUL.
For in struggling for SELF KNOWLEDGE
Is it possible I increase
The chances that this planet
Shall know eternal PEACE?

SEEKING BALANCE

BENEATH UNLIT CANDLE
*"The Lord will fight for you, and
you have only to be still."*
Exodus 14:14

TOMBSTONE
TOMB of the
UNREDEEMED
SOUL

BENEATH COINS WITH $$$
*"Better is a handful of quietness
than two hands full of toil and
a striving after wind.:*
Ecclesiastes 4:6

ON BASE
*"But my people have forgotten me, they burn incense to false gods; they have stumbled in their ways, in the ancient
roads, and have gone into bypaths, not the highway.."*

Jeremiah *18:15*

33

ANGUISH

I see my SOUL is wandering
In fields filled with hate.
Weeds of envy everywhere,
Where's the exit from this fate?
I roam lands filled with fine possessions.
Climb moneyed mountains topped with gold.
Now forests filled with terror,
A fear of death has taken hold.
Wherein lies the meaning?
Thoughts and feelings bring no rest.
Tell me what's required
That my SOUL endure this test.

Can YOU prove This to YOURSELF?

The SPIRITUAL PATH as an undertaking can be the most rewarding and certainly the most enduring endeavor of ONE's life. On this path ONE can discover who ONE IS and how ONE's 'sense based' thoughts and feelings take the REALITY that is YOU. MEDITATION, PROPERLY GUIDED, can lead to the SEPARATION of the SEE'ER from that 'which must be seen'. The SEE'ER is part of the ONE REALITY. What is seen is part of an unreal unfolding play.

To what extent do I RELATE TO or PLAY the given part?
WHAT IS REQUIRED OF ME?
WHAT DO I NEED?

FALSE DESIRES and ME

O LORD I'm like the actor
Who does not like his part.
Who wants to be the hero
Not the ass who draws the cart.
And this desire is MY prison.
It will not let ME free.
Unless I simply WATCH it
And KNOW it is not ME!

THE COMEDIAN

GOD has dressed ME as a clown.
Jolly, joking — but deep down
Questions without answers burn.
Injustice seen at every turn.

Laughter soothing to the SOUL
T'is but a pause — on to the goal.
Where JOY is BOUNDLESS — never done.
Where I and THOU shall BE as ONE.

The Drug DEALER

Humor is the "narcotic" for the SOUL — and I am just a "pusher".
Someday, perhaps, with GOD's help I'll meet the "SUPPLIER"!

SIMPLY SEEING IS "NOT DOING"

Now here's an idea to start 'chewing'.
T'is the thought of simply 'NOT DOING'.
It's an idea that's quite strange
To bring about change
But I guess it's worth the pursuing.

So commence doing this effort 'NOT DOING'.
Try too hard and your face starts a blueing.
SEE GENTLY — feeling and brain.
Take it easy — don't strain!
Cause in DOING 'NOT DOING' YOU'RE DOING.

Allow the physical discomfort, feeling or thought to arise
and bear the RIGHT RELATIONSHIP to it.

DOERS

There are those who talk
And those who "DO".
The talkers many
The "DOERS" few.

" . . . OURS IS BUT TO DO" NOT DIE.

GOD in HIS WISDOM has WRITTEN the SCRIPT
So everything's fated from cradle to crypt.
WORK RIGHTLY WITHIN and let the days flow,
The years will go by but INSIDE YOU'LL GROW.

This, Too, SHALL PASS

"Why" he asked, "do the wicked prosper?"
"Because," HE said, "it was one way
To AWAKEN man from his slumber
And teach him of the NEED to PRAY."

"But why should I who seek to serve THEE,
Whose life is filled with daily PRAYER,
Suffer so, while pain pursues me."
I ask THEE humbly, "is this fair?"

"Understand," HE said, "this life is fleeting.
Its script soon turned to dust.
But YOU, the SOUL, are EVERLASTING
So continue PRAYER and PRAY for TRUST."

THERE ARE NO ATHEISTS IN FOXHOLES

The PATH is an ESSENTIAL PATH. To embark on it ONE must have both a body and a SOUL.

It is a PATH open to all human BEINGS everywhere regardless of race, religion or gender. And with the increased UNDERSTANDING found along the WAY the qualities of MERCY, COMPASSION, JUSTICE, PEACE, HEALING, AND FORGIVENESS may begin their triumph over man's predisposition toward misery and war. A mankind striving against 'sleep' would less require scripts filled with evil to keep HIM on the PATH toward AWAKENING. Perhaps "Peace on Earth" would become a reality and not just a dream.

With AWAKENING would come a TRUE UNDERSTANDING of the line, "All the world's a stage and all the people players."

The UNKNOWN SOLDIER

SPEAK to ME in 'words' so kind,
That there's no question in my mind,
That what's REQUIRED is 'TO BE'
For 'Peace on Earth' – my SOUL set FREE.

In time I'll leave with name unknown.
No man shall see the SEEDS I've sown.
While vanity shall find its grave
I PRAY for YOU my SOUL to SAVE.

CHAPTER 5

HOW CAN I SHARE?

The effort one puts into an honorable 'earthly' activity becomes its own reward. To bring that effort to the LEVEL of an EFFORT in a HIGHER REALM ONE must SEE one's behavior IMPARTIALLY.

Only EFFORT or PRAYER, PROPERLY GUIDED and PROPERLY PERFORMED, can lead a human BEING to activity in a LASTING and HIGHER SPHERE.

And to the REALIZATION of the importance of behavior which embraces "Do unto others as you would have them do unto you."

WITHIN AND \mathfrak{A}BOVE THE \mathfrak{R}ITUAL

Once upon a time, in the not too distant future, there was a PLACE that existed at the confluence of fourteen different countries. It was known as the KINGDOM OF NOTHINGNESS and was ruled by an invisible SUPREME BEING. As time went by it became known that this KINGDOM had developed the ability to produce such things as MERCY, COMPASSION, JUSTICE and PEACE. As these treasured items hardly existed in its fourteen surrounding neighbors a means had to be developed so that they could be exported in return for 'proper payment'.

It came to pass that each of these countries, according to their individual customs, developed 'different forms' of PRAYER and RITUALS which they then presented to exchange with the BEING authorities representing the SUPREME BEING of the KINGDOM OF NOTHINGNESS. And in each case where INNER EFFORT and AWARENESS were joined to their presentation a means of trade was established.

As time went by, however, each of these groups began to feud with one another. "My WAY is better than your WAY!" "My WAY is the 'only' WAY!" Verbal assault turned into physical violence. HUMILITY and TOLERANCE were replaced by arrogance and conceit. New PRAYERS and DEVOTIONS were introduced which in time also succumbed to 'vanity' and 'sleep'.

The result of all this soon became apparent in the KINGDOM OF NOTHINGNESS. MERCY, COMPASSION, JUSTICE and PEACE began to accumulate and had no place to go. Sadness and consternation followed. How could man be shown the TRUTH of his situation? How could INNER EFFORT and AWARENESS be reestablished to prepare the way? Could REAL TEACHERS be sent with ESSENTIAL WAYS OF PRAYER and with the 'ability to infuse the old forms and rituals' with LIFE so that man would look not at the differences in forms but rather seek the ESSENTIAL TRUTHS they were meant to convey?

If a man be clothed in fine clothes or rags is he not underneath these outer garments still a man?

And if a SOUL be clothed with different feelings, thoughts and color of skin is HE not still a SOUL?

And if the SOUL struggles toward the TRUTH by way of whatever REAL WAY is chosen, is not the struggle itself a symbol of what is important and pleasing to the SUPREME BEING?

Can man be led to search for the exports from the KINGDOM OF NOTHINGNESS? And does not any search require REAL QUESTIONS?

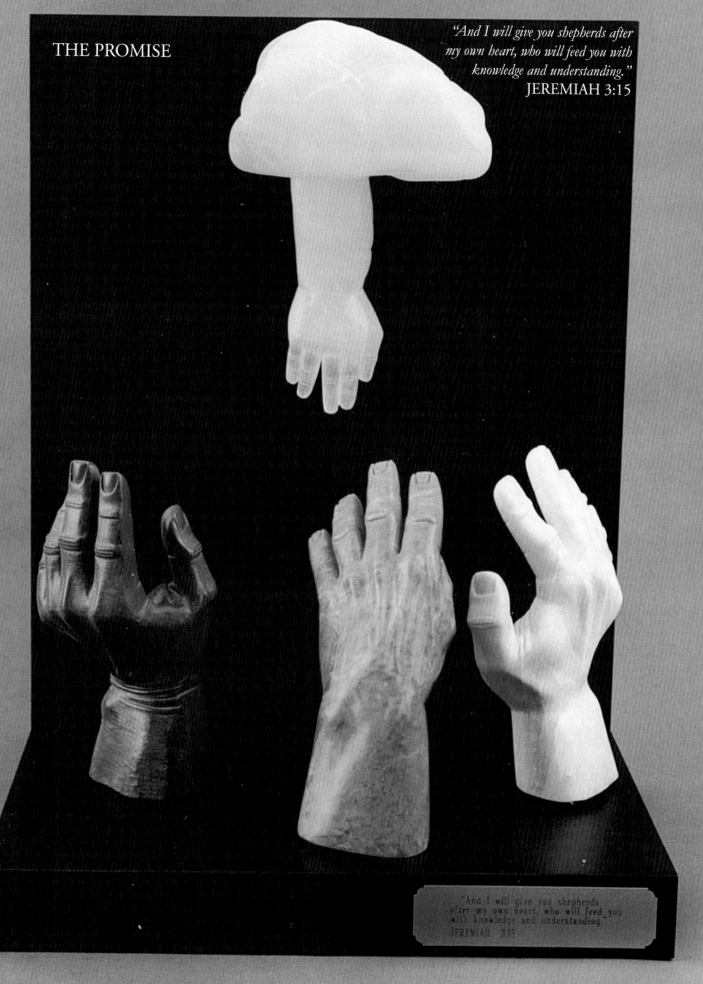

THE PROMISE

"And I will give you shepherds after my own heart, who will feed you with knowledge and understanding."
JEREMIAH 3:15

39

QUESTIONS WORTH ONE'S PONDER

Does evil exist for the sake of a HIGHER GOOD not understandable
to the limited three dimensional mind of man?
Does evil more readily turn a man inward — toward PRAYER?
And if so is a HIGHER NEED fulfilled?
Is "All the world a stage and all the people players."?
If so, then what is REAL in man?
How can I find this REALITY in me?
And what serves this HIGHER NEED —
the SEARCH or the FINDING of this REALITY? Or is it BOTH?

". . . . Judgement and Justice Seize you."
JOB 36:17

I SEE there are 'right' feelings.
'Right' thoughts come into view.
And when they're SEEN together
'Sense of justice' starts to brew.

This feeds fear and consternation.
I SEE sadness and despair.
For my 'sense of justice' traps ME
With an anger hard to bear.

I SEE the atheist in me arising.
I SEE he wants to know,
"How can GOD be in HIS HEAVEN
And let injustice grow?"

Is there an explanation
For 'earthly' heart and 'earthly' mind
That can soothe my 'sense of justice'?
I have sought — I cannot find.

So I ask myself the question,
"Is this a script, a play, a scheme?"
If from within I SIMPLY VIEW it
Will I SEE it's just a 'dream'!

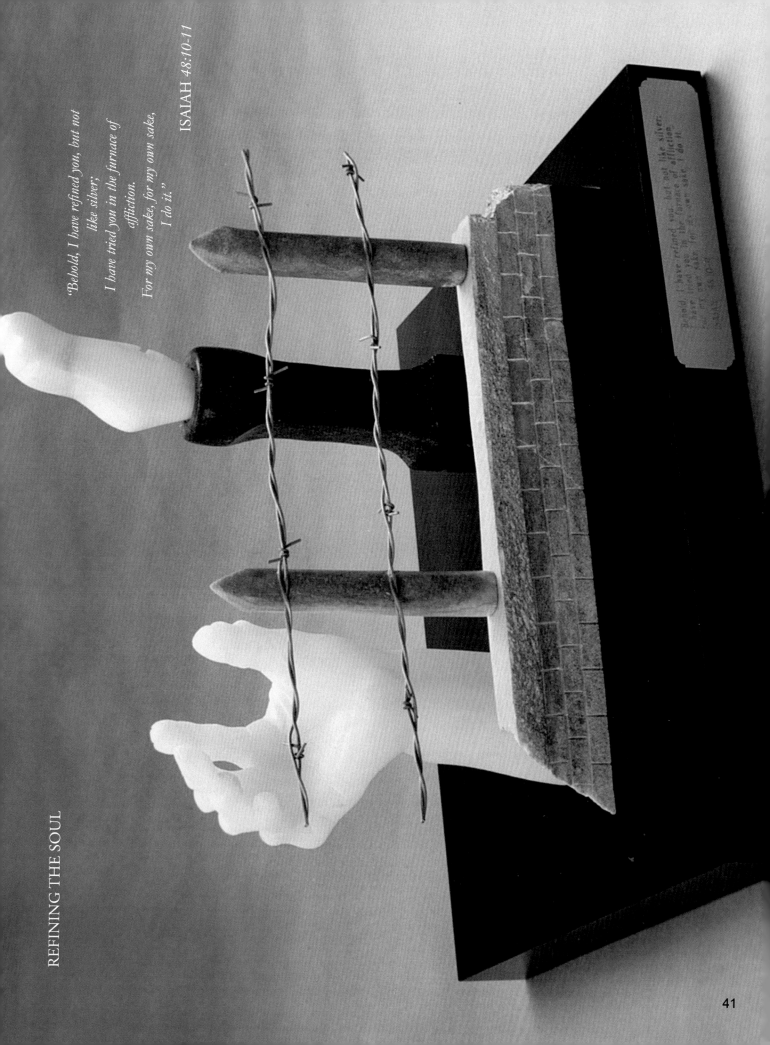

REFINING THE SOUL

"Behold, I have refined you, but not like silver; I have tried you in the furnace of affliction. For my own sake, for my own sake, I do it." ISAIAH 48:10-11

41

LEVELS OF UNDERSTANDING

The stone is cast into the sea.
I do not know from where.
And the message written on it
Is a TRUTH for all to share.
Those closest to its landing
The PUREST TRUTH for them be known.
And for those that now stand far away
The TRUTH's gentle ripples shall be sown.

A WISH

Protect ME LORD from fame and fortune.
Plunge ME not in stress and strife.
Grant ME LORD THY PEACE and PRESENCE
That I may 'taste' ETERNAL LIFE.

IMAGINING THE ETERNAL

Take ME to a place of peace
Where fear is gone and troubles cease.
Where perfumed flowers fill the air
And life is lived without a care.
Where soundless sounds enchant the ear
GOD'S PRESENCE hovers—oh so near.
And vistas grand suffuse the eye
While sculpted clouds go scudding by.
Where mountaintops and skies do meet
Pine needle carpets 'neath' my feet.
And babbling brooks broadcast their song.
At peace I'll be, 'twixt right and wrong.'
Where placid waters kiss the shores
And life's eternal spirit soars.
This is the place—I shall not roam
For surely, Lord, YOU'VE brought me home.

CHAPTER 6

WHAT IS MY PLACE?

" AND A ᴅOOR SHALL OPEN

Nailed to this pain and pleasure
MOMENTS only can I treasure.
Free from both and close to THEE
SENSING IMMORTALITY!

A ᴘRAYER

This is the script I've been given.
This is the part I must PLAY.
Give ME the STRENGTH to ENDURE it.
Teach ME, O LORD, how to PRAY.
For COURAGE and all that flows from it.
For PATIENCE to get through the day.
For PERSISTENCE in the face of all evil.
That I AM at the end of the fray.

" OR NOT TO ᴮE"

Earthly joy and earthly sorrow
Two imposters — both the same.
Lost in one or the other
BEING does not play the 'game'.

For everything there is a season and a time for every matter under heaven: a time to be born, and a time to die; a time to . . .

ECCLESIASTES *3:1-8*

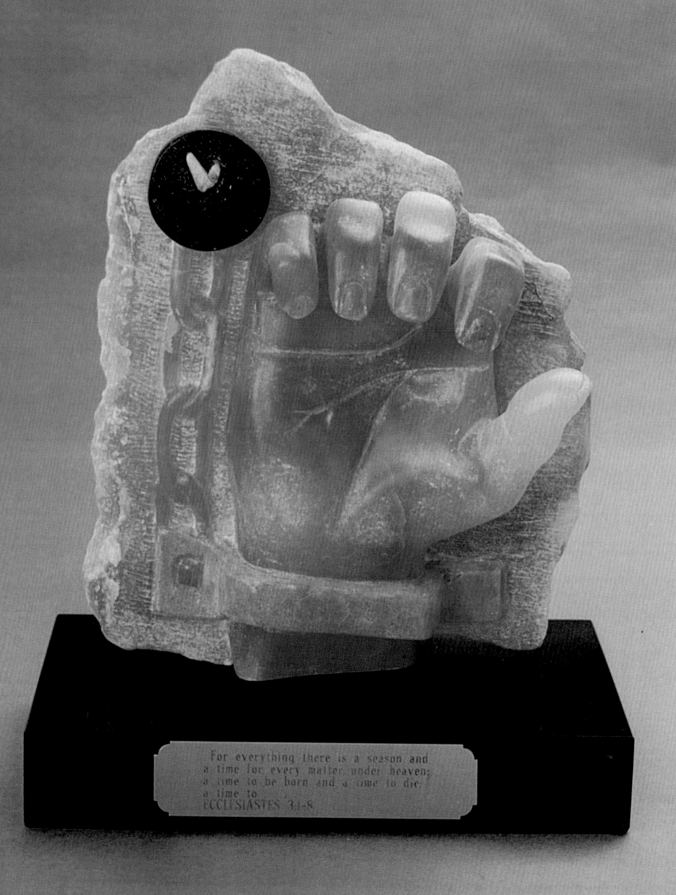

AMATEUR NIGHT

Our GOD looked down from HEAVEN
For the BEINGS HE had sent.
To PLAY the parts HE'd WRITTEN
To teach man his life's intent.

But, alas, these BEINGS faltered
And the problem seemed to stem
From the actors—not BEING actors
For the parts were playing THEM.

AM I the part I play?

O LORD protect ME from the part
That I shall have to PLAY.
And if it be heroic
From the praise of men I PRAY.

But if it be the devil
Please free me from their hate.
That I may walk with gratefulness
Straight through the 'pearly gate.'

ONE SEAT IN THE BALCONY PLEASE!

If all that is to be is written
Why with power am I smitten?
Why not sit back and SIMPLY SEE
The fool that's justly known as me.

FOR GOD'S GRAND CHILDREN

Life is really just a play
In which we try TO BE each day.
Our CREATOR served with all our heart.
AWAKE within the given part.
At age fourteen it's still 'Act One'.
Your play has lifetimes yet to run.
So do your best and learn the 'score'.
And then come knocking on GOD'S DOOR.

ℬody awake but 𝔖oul asleep

Once upon a time – not very long ago – there lived in a faraway place a family of fourteen children. There were seven brothers and seven sisters. Their Father was an actor and well-regarded in his profession for his ability to play all kinds of roles while maintaining – as the critics would say – "a great SENSE OF PRESENCE."

Now among all of these children, there were two, one brother and one sister who seemed to inherit this TALENT from their father. Having reached the age of responsibility they announced that together they intended to leave their devoted family and travel to the city to make their fortune. It was a trip which for them was 'light years' away both from home and the values they regarded as important.

Success was almost immediate. As luck would have it they were both hired by the same studio and began to assume roles opposite to and often antagonistic to each other in the same movies. At first, the strength of their ESSENTIAL NATURES seemed to protect them against the subtle pressures that come with prestige — and the power that usually follows. With time, however, they began to slip into the roles they had been playing. The younger brother having been given parts that most often represented humility and goodness, began to have difficulty because his REAL NATURE was so closely aligned with the part to be played. The quality inherited from his Father — that of a SENSE OF PRESENCE — began to dissipate. His older sister having been assigned roles embracing arrogance and evil also became similarly affected — SHE, too, began to disappear into the written script. But in her case this result came about because of her success and the love that the local populace seemed to have for arrogance and evil. Their fawning and adoration gave her a sense of power — at the expense of a SENSE OF PRESENCE — so that with time her ESSENTIAL NATURE all but disappeared.

It was their Father who first began to notice what was happening — His children had lost that important SENSE OF PRESENCE and were no longer actors — they were 'asleep' in their parts. But, what to do? To bring them home as they were would bring shame and disgrace upon the whole family. The question was pondered and it was decided that their youngest brother be sent. In the time since they had left home he had grown from a young child into manhood and had become an unrecognized but TALENTED TEACHER of "THE ART OF RETURN TO REAL PERFORMANCE." Not only was his TALENT unrecognized but so was his physical appearance to both his now much older sister and brother. With the help of his Father the younger brother enticed his older siblings, along with others similarly afflicted, into classes at a newly established school. His methods were 'gentle'. Return to SENSE OF PRESENCE was a GRADUAL PROCESS marked by PERSISTENT EFFORT and rewarded at first only periodically with MOMENTS OF UNDERSTANDING. Like a sculptor who starts with an irregular block of stone and chips away to find the beauty in the essential shape hidden within it — so it was for those who persevered. That which was theirs to begin with became once again their most treasured KNOWLEDGE with the result that forever relegated good and bad, joy and sorrow, success and failure and all their kin to the scripts for which they were intended.

The Ᏽenie in the Bottle

I'm like the genie in the bottle
That has been thrown into the sea.
And the waves have tossed the bottle
And have not been kind to me.
So with PATIENCE and PERSISTENCE
I PRAY for yonder shore.
Where the bottle then be broken
I'LL be FREE forever more.

THE Ᏽatient and PERSISTENT MARINER

I set my sails from here to there.
PRAYER and EFFORT ARE my fare.
Lifetimes come and lifetimes go;
MYSELF 'in time' I'LL get to KNOW.
Along the WAY I may take on fear;
No answers come as to WHY I'M HERE.
PERSISTENCE, PATIENCE are a must
To seek THY PRESENCE and THY TRUST.

A Ᏽuestion. ANSWERS LEAD TO MORE QUESTIONS

What HIGHER INTELLIGENCE put ME in the position I find MYSELF in?
Surely, something must be required of ME.
All men, regardless of race or cultural background, walk the Earth in the same basic human form.
Each human BEING has the same opportunity to SEE 'WHO HE IS NOT!
The perch from where HE views himself will reveal differing thoughts, feelings and sensations
from other OBSERVERS who are making this same EFFORT or PRAYER. The OBSERVER
is not the 'observed'! The SEER is not the 'seen'!
The measure of a man's BEING is proportional to the degree of IMPARTIALITY with which
HE SEES himself.
It is best to be simple. Locked as WE are to this three-dimensional machine can WE understand
a multi-dimensional universe?
Can KNOWING MYSELF lead to an understanding of GOD's purpose in placing ME here?
Am I a link between this three-dimensional existence and a higher dimension?
Is GOD's need served and does it continue to be served only when WE are searching?

CHAPTER 7

WHAT IS POSSIBLE?

START WITH, "I AM HERE."

RISE ABOVE the ritual.
The fleeting thought laid bare.
The passing pain and sorrow.
Let BEING be YOUR PRAYER.

BEING is 'SENSE OF PRESENCE'.
Yet no words can make it clear.
But GOD will KNOW YOU'RE trying
When YOU simply say, "I'M HERE!"

FIVE SENSES HAZE

YOU wake ME up in many ways
From 'waking sleep's' five senses haze.
To SEE, TO BE, and thus fulfill
THY NEEDS — and so I climb the hill.
Each day proclaiming "I AM HERE!"
Freed from joy and freed from fear.
I sit and WATCH and when it's ME
I SENSE THY PRESENCE — quietly.

SEEKING The SEER in me.

Man must realize WHO HE IS and WHO HE IS NOT! As HE WORKS is HE the
SEE'ER (SEER) or the 'seen'?
He must SEEK A PATH that will answer the above question 'gradually' over time.
In so doing does HE serve both a HIGHER NEED and LIFE'S PURPOSE here on Earth?

2 QUESTIONS to PONDER

Does GOD need "TO BE"?
Is it then that HE grants the GIFT of HIS
DIVINE PRESENCE to those who are seeking?

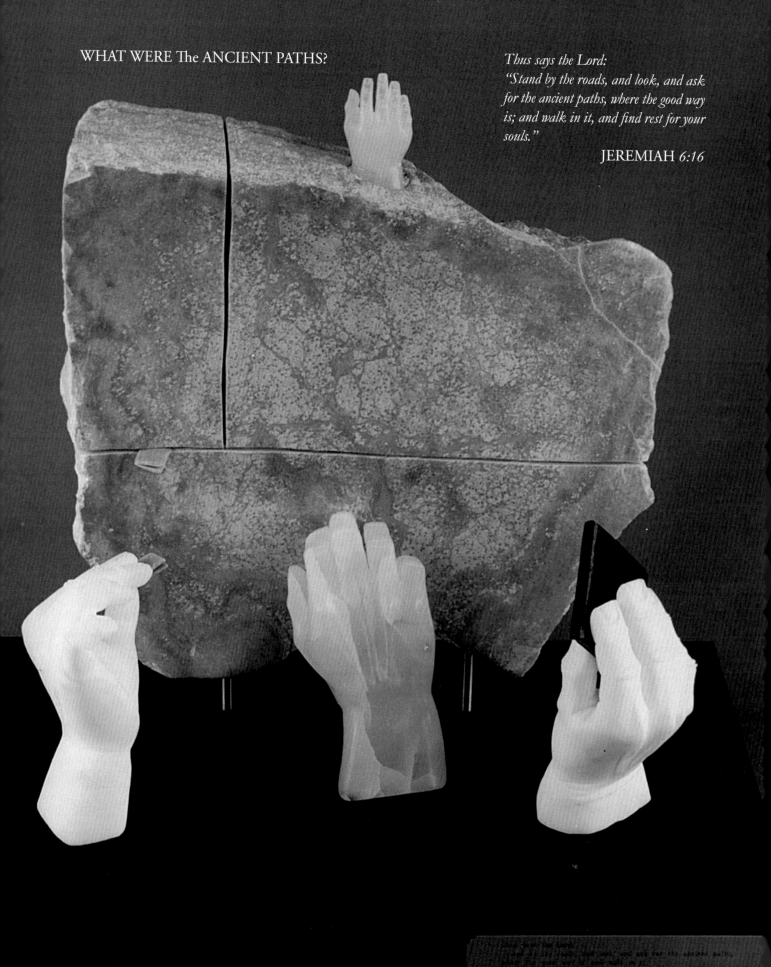

WHAT WERE The ANCIENT PATHS?

A **P**ARABLE—from a translation of the writings of HU MAI.

Once upon a time in the Chinese province of BEYING there lived a famous warlord by the name of LEH TSE. It was his custom, that on the seventh day of every week, he would turn from his normal activities to bring, as he would say, "My mind, my body and my feelings into harmony with the ONE AND ONLY GOD."

To satisfy this desire he would arise two hours before dawn to set out on the journey to the TEMPLE MOUNT which was located atop a nearby mountain. As his earthly body had become worn with the years he could no longer make the ascent on foot and required the help of two of his servants. The rickshaw-like device used was common to that era. It consisted of two twelve foot long poles to which a covered chair was attached in the middle. LEH TSE would take his place hidden from the porters and then, when he was properly AWARE, gave the order to start the climb.

The two porters who always attended him on this weekly trip were actually twin brothers. One was called YIN and the other YANG. Although alike in physical appearance they were direct opposites in their thoughts and feelings. While YIN approached everything with positiveness and enthusiasm his brother YANG was negative and sullen. LEH TSE having been given DIVINE WISDOM recognized the difference and so placed YIN as his front bearer and YANG in the rear. YIN with his right attitudes and desire to serve would assure LEH TSE that he would gain the Temple Mount by sunrise. And YANG would act as a counterbalance so that YIN's rushing upward would be slowed — and SIX REST STOPS MADE — so that the parts of LEH TSE's earthly body could gradually become accustomed to the ever increasing altitudes. The trip that day, as always, went as had been foreseen. They arrived just below the summit before dawn. The MASTER was helped from his chair and leaving YIN and YANG behind HE climbed the last remaining incline to the TEMPLE MOUNT. Free of earthly encumbrances HE was granted the EXPERIENCING of the PRESENCE OF THE ONE AND ONLY GOD.

When HIS devotions were complete HE returned to address the two brothers. "As you have each in your own way contributed equally to my safe arrival here this morning so shall you each receive equal payment." Having said this HE ordered them to each occupy one-half of the covered chair and when they had done so HE lifted it and carried them both back down the mountain — MAKING SIX STOPS ALONG THE WAY.

FINDING THE BALANCE PLACE

My FATHER is the author.
HE writes poetry in my name.
And if it should be well-received
Can I survive the 'fame'?
And if critics find it shallow
And from 'fame' I fall to 'shame'
Will GOD give ME the WISDOM
To SEE both of them the same.

BLESSED ARE THOSE

What does GOD need?
HE needs your BEING EFFORT in the face of all the joys and sorrows embodied in the script given to you.
Is there meaning to life on earth?
Meaning lies with the STRUGGLE along the PATH to SELF-KNOWLEDGE and a REBIRTH or REDEMPTION of the SOUL.
Blessed are those that strive to do 'good' and meet with 'unjust' failure.
Blessed are those who struggle with pain — be it physical, mental, emotional and especially spiritual.
Blessed are those who are graced with a sense of humor to counter their own vanity.
Most blessed are those who can retreat to the SANCTITY of their own BEINGNESS in the face of all earthly evil and in so doing approach the hallowed and INFINITE MERCY, COMPASSION and ONENESS of the CREATOR.

ANCHOR'S A WEIGHT

I SEE the frenzy of the mind.
Without ONE'S SEEING, ONE is blind.
To imagined fears, suspicion, hate.
Please lift MY anchor from this weight.
Let MY COURSE be straight and true.
Fill MY sails with LOVE of YOU.
That BALANCED EFFORT does not cease.
While BEINGNESS shall thus increase.

When BEING is AWAKE

I hear a different DRUMMER.
HE plays a different tune.
I hear HIM in the morning
And in the afternoon.
I hear HIM in the evening
And when the day is done.
I TRUST that HE'S THE DRUMMER
And that someday WE'LL BE ONE.

A TOAST

To the BEING of Mr. (Mrs.) X.
And the BEINGS who struggled with HIM(HER).
And to the BEINGS who struggle with HIM(HER) NOW!
For that ONE NOTION INDIVISABLE
With its promise of LIBERTY AND JUSTICE FOR ALL.

A PRAYER FOR PATIENCE

Somewhere GOD's PEACE is waiting.
Somewhere does JOY abound.
Oh FATHER give ME PATIENCE.
Until this PLACE is found.

A PRAYER FOR COURAGE

O LORD take terror from my heart
That I FULFILL the given part.

Puppets

Warring puppets move across the stage
Filled with hate and filled with rage.
A 'string is pulled' — the rage does cease.
And now the puppets sign for peace.

The rage returns — the peace is gone.
The blood is spilt and bodies torn.
Is there meaning in this script?
'Where strings are pulled and switches tripped.'

Of course, there is no sense to this
Where everything is so amiss.
So teach ME LORD to LOOK within
To serve THY NEED — a SEARCH begin.

To SEE the wayward 'string-pulled' thought,
Desires, feelings come to nought.
To SEE the puppet — let him be.
And this WAY KNOW — it is not ME.

The Fear of Death

This 'fear of death' — 'it' wants 'its' say.
With thought and feeling does 'it' play.
To bury TRUTH with body's fear.
To stop ME KNOWING "I AM HERE".
My shield's in place—the lines are drawn.
I shall not be this body's pawn.
For 'fear of death' shall turn to dust.
While I shall serve a TRUTH that's JUST.

What is Real?

Be not afraid to be afraid.
Earthly fear is but a dream.
Turn inward and begin to see
Things are not what they seem.
REALITY is the SEE'ER
Who judges not the plot.
And when HE is this viewer
What HE sees is what HE'S not.

Eulogy

Oh GOD'S creation made of LOVE
Why have you left and gone above?
And I remain with spirit torn
Oh dearest friend since I was born.
Return to me and heal my SOUL
That I go forward to the goal.
The 'game' be played — the DEEDS be done.
And then I'll die and WE'LL be ONE.

CHAPTER 8

WHO GUIDES ME?

ℌEAVEN

How is it all in HEAVEN?
Is there good and is there bad?
Are there 'things' that make YOU happy?
Are there 'things' that make YOU sad?
Are there ethnic groups divided?
Is there 'white' and 'brown' and 'black'?
If there is O HEAVENLY FATHER
Be sure to send ME back!

A ℙROPHECY

I SEE a stadium filled to the brim.
The sun arising o'er Earth's rim.
The crowd in silence sits and waits.
Each SOUL at WORK — anticipates.

Each SOUL IS FOCUSED ON ITS FORM.
This MEDITATION now the norm.
There are no teams — no bands do play.
No empty words do speakers say.

Hindu, Buddhist, Christian, Jew,
Muslim — and all others too
Side by side in PRAYER they plead
For GOD to COME and FEEL THEIR NEED.

That each shall KNOW LIFE's purpose here.
That LOVE replace all hate and fear.
That PEACE shall reign and not the gun.
That then they'll KNOW that ALL IS ONE.

ALL IS 𝕆NE

BLESSED IS THE LORD WHO TRUSTS in the BEINGNESS of man,
WHOSE TRUST IS the BEINGNESS of man.

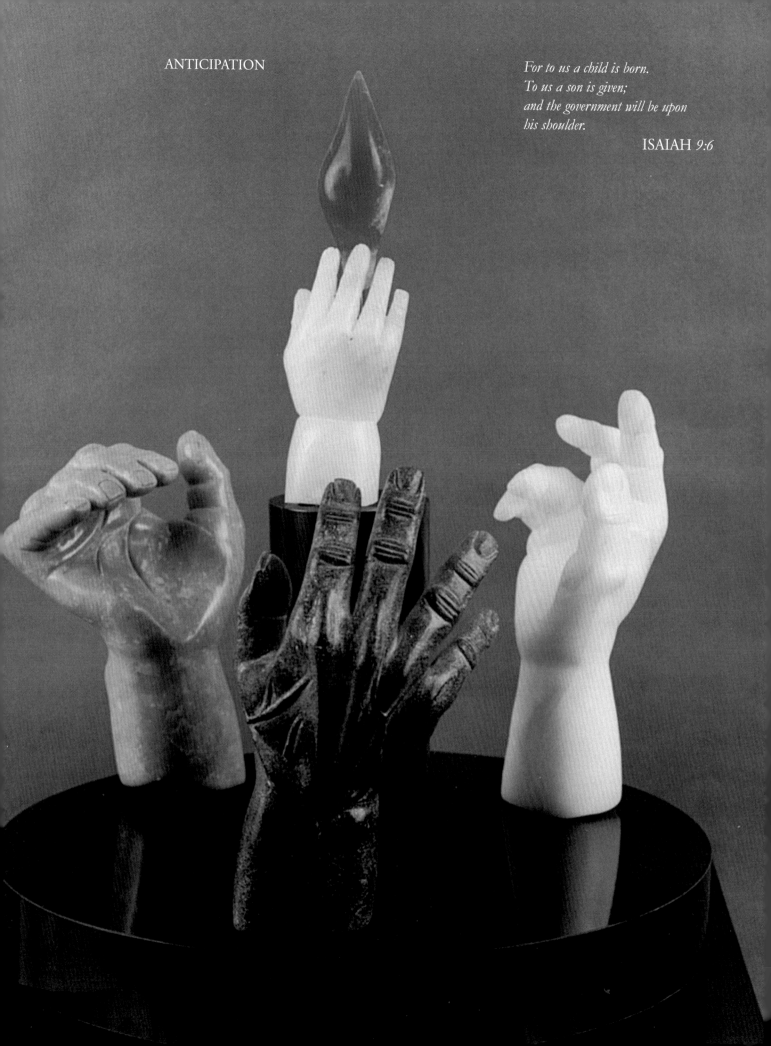

ANTICIPATION

For to us a child is born.
To us a son is given;
and the government will be upon
his shoulder.

ISAIAH *9:6*

Healing and Forgiveness

". . . vanity of vanities! All is vanity."
ECCLESIASTES 1:2

Ego-eggo sat on a wall.
Ego-eggo had a great fall.
All the professors and all the wise men
Couldn't put Ego-eggo together again.

But GOD with HIS power took Ego and tried.
And HE refitted the pieces – side to each side.
And with a great push put him back on the wall
Where he could be seen by one and by all.

Now Ego did speak in a humbler tone.
A sign that within WISDOM had grown.
And coupled with fervor he made quite a sight
As through unhealed cracks there now shone a bright LIGHT.

And the LIGHT was a beacon that woke men from their sleep
To the needs of their FATHER – which would not long keep.
Thus the Earth became peaceful – a place that was blessed.
Now a planet recovered – at ONE with the rest.

"Blessed is the man who trusts in the Lord.
Whose trust is the Lord."

JEREMIAH 17:7

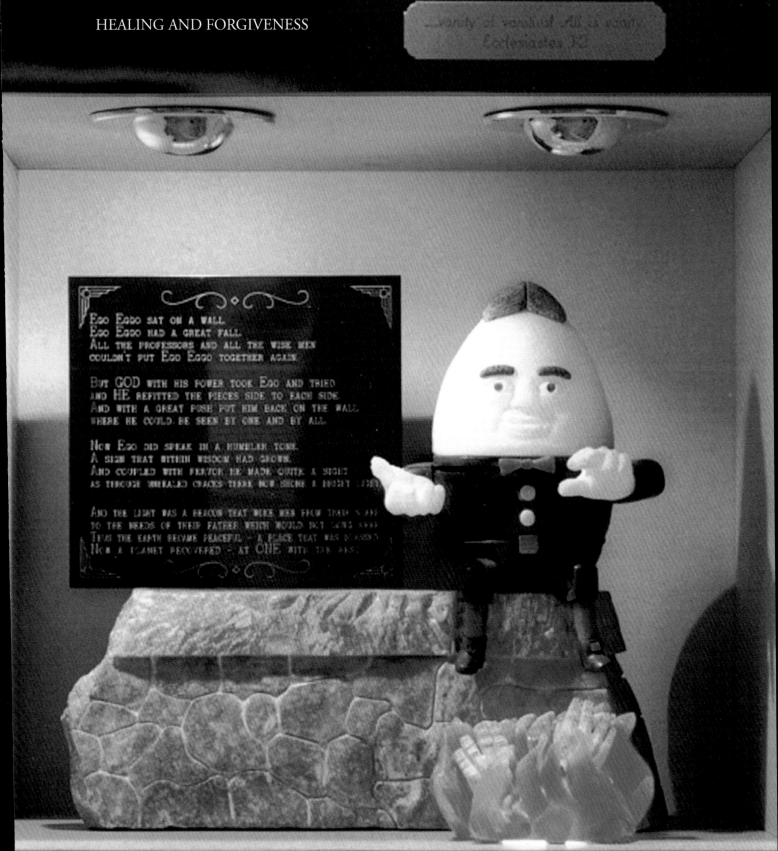

VANITY OF VANITIES

This "VANITY OF vanities"
Is hard to understand.
IT's not the same as vanity
IT has a level much more grand.
So when I WATCH my vanity
IMPARTIALLY and from ABOVE,
I'LL get to KNOW my REAL SELF
Also KNOWN as "VANITY OF".

WITNESS FOR THE 'poetician'

My vanity takes ME for itself
in all the words i say.
And when a poem like this is writ
of vanity I AM the prey.
Protect ME from myself dear GOD
that I may live this day
In PEACE, in PRAYER, in KNOWING
T'is but a poet's part I PLAY.

REAL TEACHER's CONSTANT STRUGGLE

O vanity why would you take
This INNER EFFORT that I make.
To serve your wish for earthly fame.
To have ME known by thy last name.

A ROLE for Vanity

Lead ME not down vanity's path for vanity's sake but only for THY needs.

AT ONE WITH REALITY

When I AM, then that which I AM 'not' can be SEEN to embrace all that my three-dimensional mind and feelings tell me is either right or wrong, good or bad, happy or sad.
TRUE RIGHTNESS, GOODNESS, and JOY lie in BEING.
In BEING, I AM there in the script but free of it — a SENSE OF PRESENCE.

BIRTH PAINS

Acorn fallen from the tree
Much sympathy you have from ME.
Seek the earth and wish within
To find YOUR WORK — while oak begin.
Though in your heart desire's right
Fear not the slowly passing night.
Seek the TRUTH to set YOU free.
And look to GOD — HE'LL make the tree.

A CRY FROM ATOP THE MOUNTAIN

My SOUL lies panting on the floor.
I hear the cry, "No more! No more!"
I need the help of ONE above
That I may WORK to share my LOVE.
LOVE is BEING.
LOVE can DO.
For PEACE 'mongst men —
And ONE with YOU.

THE UNRECOGNIZED REAL TEACHER

Once upon a time, on the highest plateau just beneath the peak of MOUNT WISDOM, stood a stand of mighty evergreen trees. The location was often referred to as the PLAIN OF KNOWLDEGE AND UNDERSTANDING. It was rare and unusual to find this specie of tree at a height and in a location such as this — an altitude where any vegetation at all was scarce and hardly ever seen.

The plateau itself was no more than 40 yards square and fell off steeply and abruptly on all four sides to rushing stream beds which encircled it completely. The trees received their nourishment from both the sun, which the highest branches seem to touch, as well as the water from the streams which permeated the soil embracing their root systems. The trees were now quite aged and the process of perpetuating the WISDOM and UNDERSTANDING given to them required the seed cones dropping from their branches to find root in the soil of the plateau to produce a new generation. Over many years this had indeed taken place. Now, however, the subsequent growth of the new trees was being inhibited by the lack of sunlight, which could not reach them owing to the complete darkness of the environment created by the branches of the older and taller trees. The younger trees having passed beyond the years in which growth could take place remained stunted and unable to produce the necessary seed cones even after the demise of their progenitors.

As chance would have it some of the seed cones of the original trees rolled off the plateau, down the steep embankment and into the pure water of these higher level streams. Most were washed away, but one managed to land on a small patch of soil between some huge boulders which protected it from the rushing waters. This SEED with much PERSONAL STRUGGLE and UNSEEN HELP managed to take root and in time began to grow in stature owing to its unrestricted access to both sun and water.

The existence of this EVENT was perceivable to the older original trees on the plateau owing to their height but not to the stunted generation struggling in the darkness of their shaded environment.

In time the roots of this stream-located tree embraced the boulder nearest to it and with this firm foundation grew taller and taller until it reached a height above the plateau and above the stunted trees which were now all that remained on the plateau itself. The growth of the trees on the plateau, because of their lack of maturity were unable to pass on the attributes of KNOWLEDGE and UNDERSTANDING. Whereas, their brother, growing 'isolated' and 'unaccepted' produced hundreds of seeds, many of which went downstream, to larger and larger rivers where they took root at all LEVELS and in all places conveying within them the ORIGINAL KNOWLEDGE and UNDERSTANDING from MOUNT WISDOM.

The sculpture on the opposite page is entitled "ALL THE ANSWERS, NO QUESTIONS"

This is also the title of the lecture series noted on the announcement which is posted to the left of the represented speaker, 'Professor Doctor Noah Tall.' The quotation on the sculpture is from Isaiah 5:21 and reads, "Woe to those who are wise in their own eyes, and shrewd in their own sight!"

On the base of the sculpture is the biblical quotation from Job 28:12-13
"But where shall wisdom be found? And where is the place of understanding?
MAN DOES NOT KNOW HIS WAY TO IT and it is not found in the land of the living."

Our well-intentioned Professor's sole use of his gifted intellectuality, in this instance, is interfering with the universal desire of the SOUL TO KNOW ITSELF. His world is only the three dimensional world, of "THE LAND OF THE LIVING," as Job refers to it. In this "LAND OF THE LIVING," Job questions whether wisdom or understanding can be found here; for man does not know the METHOD or WAY to the SELF REALIZATION OF HIS SOUL.

THE MOUNTAIN CLIMBER

Nothing so thwarts the SEEKER of ONE'S SOUL
Than the glare of his brilliant mind.
For it is not the only tool with which he must dig
To uncover the TRUTH he must find.
Increased awareness of the physical body
And one's emotions, are a place to begin.
To arrive at REBIRTH or REDEMPTION,
To be able to "GO OUT OR COME IN."
Be wary of false shepherds with all answers.
Real questions are more likely the key
For a momentary sense of SOUL'S PRESENCE,
And eventually "TO BE OR NOT BE."

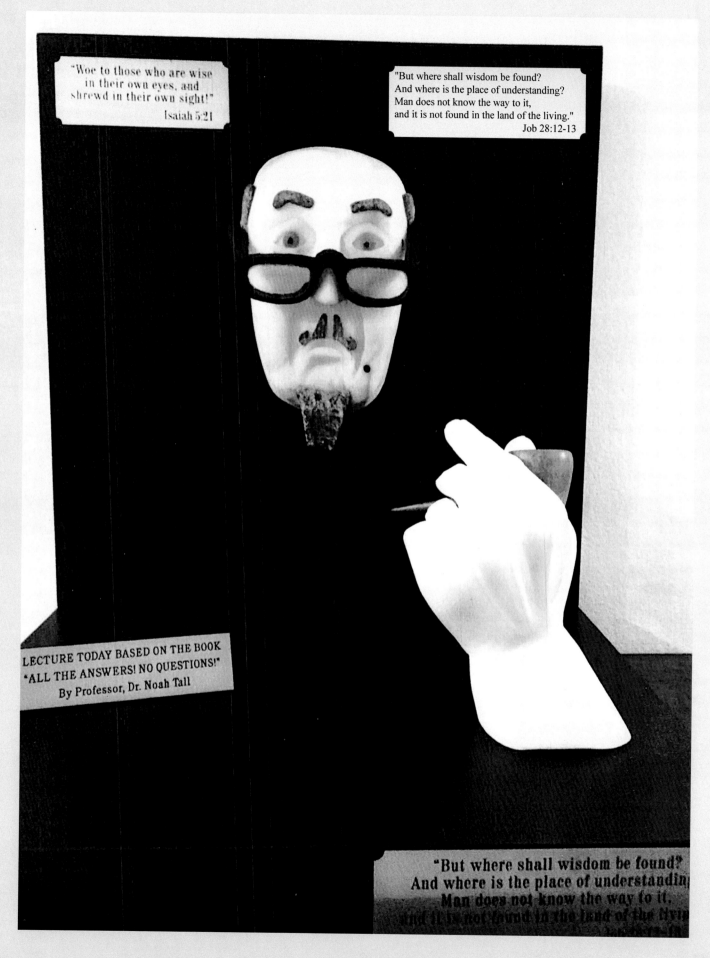

THE WITNESS

My SOUL is in rehearsal
For the part I AM to play.
As a WITNESS to a Teacher
I must try TO BE each day.
This will open up AWARENESS.
SELF KNOWLEDGE is my aim.
I pretend now to be the SEEKER
And ask questions in HIS name.
I SEE the SOURCE provides the answers.
A YOUNG SOUL'S UNDERSTANDING has begun
As to the WITNESS, SOURCE and SEEKER
For the MOMENT they are ONE.

PATIENCE, PERSISTENCE, and COURAGE

"I AM the TEACHER who has yet to teach
Whose SOUL cries out but does not reach
The BEINGS of those who lie in sleep
I'm like the shepherd who has no sheep.

What is required? What shall I do?
While patiently I wait for YOU
To show ME the PATH----MY scripted way
For PERSISTENCE, COURAGE do I pray

That I shall BE when THOU dost speak
THOU art the SOURCE for those who seek
While I AM dressed for a Teacher's role
To AWAKEN man to KNOW his SOUL

I AM but a WITNESS—I EXIST between
THY spoken word and a Teacher, seen.
Idolize not what turns to dust
KNOW who is UNSEEN is whom to TRUST.

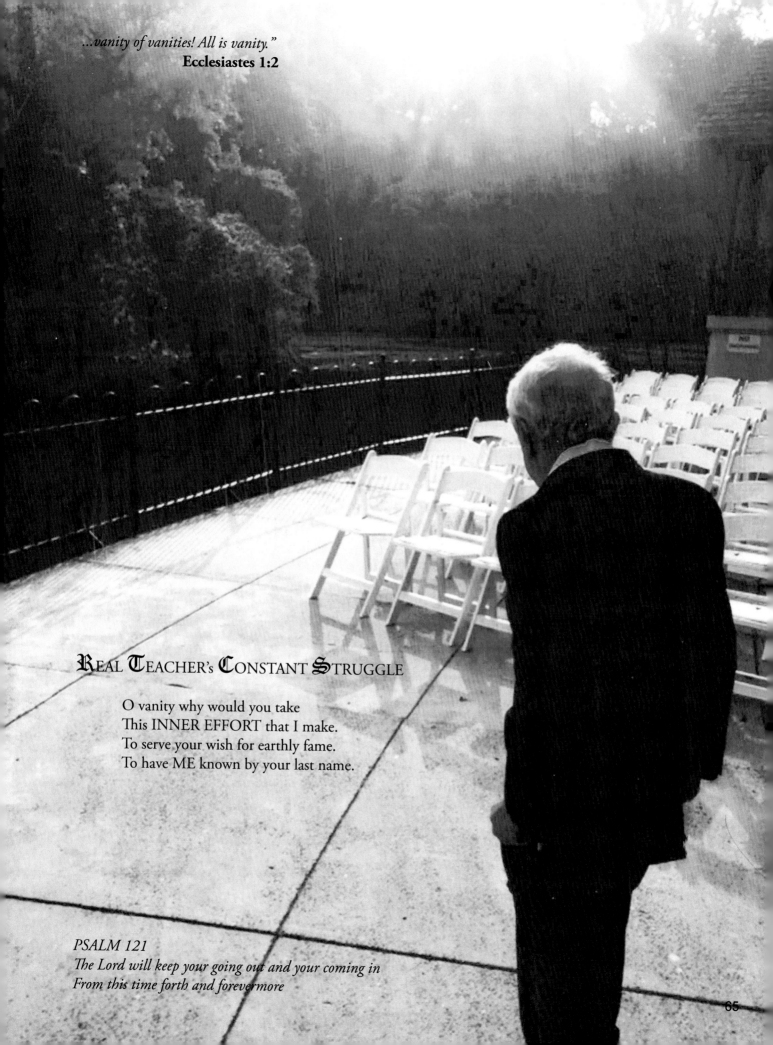

ℜeal 𝔗eacher's ℭonstant 𝔖truggle

O vanity why would you take
This INNER EFFORT that I make.
To serve your wish for earthly fame.
To have ME known by your last name.

PSALM 121
The Lord will keep your going out and your coming in
From this time forth and forevermore

Protect ME from myself

Oh LORD protect ME from myself
That I may live this day
With BALANCED EFFORT toward THY NEEDS
And CONFIDENCE l pray.
MY enemies they surround ME.
There is no place to hide.
Their leader known as 'fear of death'
Has 'negative imagination' at his side.
Behind me are 'suspicion,'
'envy,' 'anger'and 'false pride.'
Let the LIGHT of BEING see them LORD,.
Be MY HELPER and MY GUIDE.

Hold On!

"Hold on! Hold on!" These words suggest
You stay the course and pass this test.
Though night be black and filled with fear
And thought and feeling bring no cheer,
While hopes are gone and dreams are tossed
YOUR SOUL with pain in fields of frost.
Deep down YOU KNOW the sun will rise.
The TRUTH shall melt this tale of lies.
And YOU'LL BE there with GOD as ONE.
That's why!That's why! "Hold on my son!"

Postscript

Try to understand—not with the mind.
EVERYTHING HAPPENS! The script is the script.
There is no right or wrong except thinking make it so.
So SIMPLY SEE! Become a see-er (seer).
A see'er begins to KNOW HIS REAL SELF as HE SEES "what HE is not!"
SEEING frees the SOUL and leads to MOMENTS of SELF-REALIZATION
and eventually the ability "TO BE". When YOU strive to KNOW YOURSELF
(your REAL SELF) you will KNOW ME.

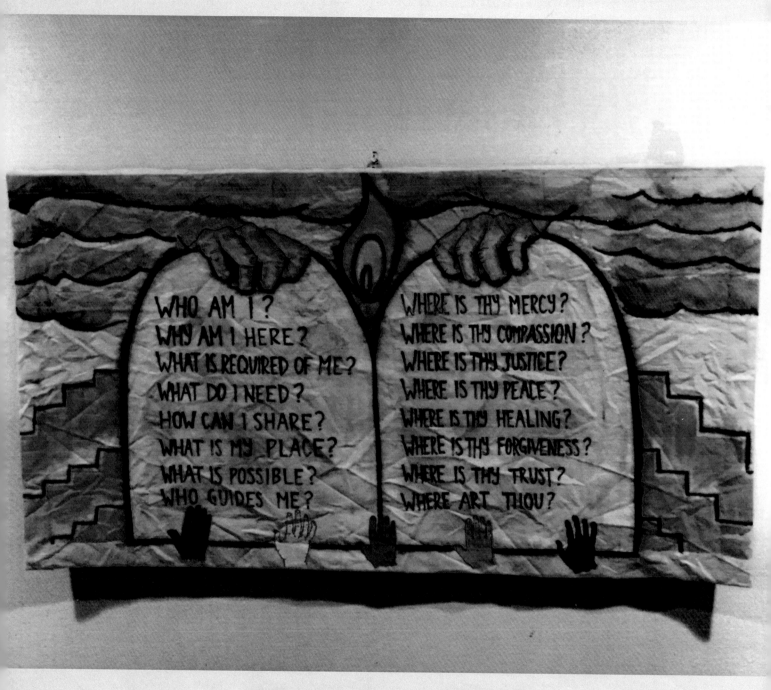

Many Questions. <u>ONE</u> answer.

Printed in the United States
By Bookmasters